JOHN CONSTABLE

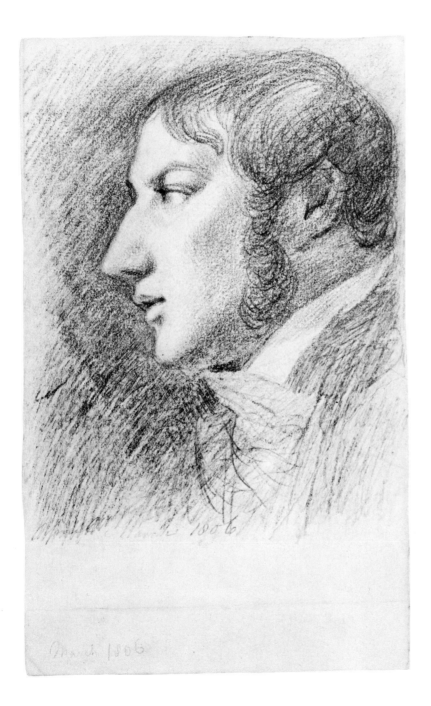

John Constable 1776–1837

by Conal Shields and Leslie Parris

THE TATE GALLERY

John Constable 1776–1837

'We see nothing truly till we understand it.'

Constable. *Lecture III.* 1836

In 1830 the Royal Academy Council, of which Constable was a member, met to consider entries for the annual Exhibition. An eyewitness reported the following occurrence:

> a small landscape was brought to judgement; it was not received with favour. The first judge said, 'That's a poor thing;' the next muttered, 'It's very green;' in short, the picture had to stand the fire of animadversion from everybody but Constable, the last remark being, 'It's devilish bad – cross it.' Constable rose, took a couple of steps in front, turned round, and faced the Council.
>
> 'That picture,' said he, 'was painted by me. I had a notion that some of you didn't like my work, and this is a pretty convincing proof. I am very much obliged to you,' making a low bow.
>
> 'Dear, dear!' said the President [Martin Archer Shee] . . . , 'how came that picture amongst the outsiders? Bring it back; it must be admitted, of course.'
>
> 'No! it must not!' said Constable; 'out it goes!' and, in spite of apology and entreaty, out it went.

The story has curious features. Constable had just been elected an Academician and therefore was not required to submit his stuff to the Council. His words almost suggest that the incident was contrived. Indeed, the canvas may, as Shee implies, have got 'amongst the outsiders' by mistake, but why was it *unrecognised*? Nobody but Constable was painting in such a way at the time: 'I had a notion that some of you didn't like my work' says Constable – but the peculiar, the Constabelian character of that work could, it seems, be invisible to those far enough out of sympathy.

When the artist's hand *was* noticed, admiration did not inevitably follow.

Learn this, ye painters of dead stumps,
Old barges, and canals, and pumps,
Paint something fit to see, no view
Near Brentford, Islington, or Kew –
Paint any thing, – but what you do.

Thus, a year after the appearance of Constable's river scene 'The Leaping Horse' (R.A.1825), wrote the Rev. John Eagles in a eulogy of Francis Danby, beside whose 'themes sublime' the interests of Constable seemed utterly trivial. While Eagles versified, Danby set about 'The Opening of the Sixth Seal': his effort for 1826 was 'The Delivery of Israel out of Egypt'.

Constable, in the face of near total indifference, incomprehension or dislike, believed he was doing something new and important: he was rightly found 'an odd fellow, and a great egotist'. When he brought out *English Landscape*, a set of prints from his compositions, Constable plainly had in mind Turner's *Liber Studiorum* and the engraved version of Claude's *Liber Veritatis*: he was asking the public to measure him against the best known landscapists of past and present. The lectures on the history of landscape painting which Constable delivered towards the end of his career were designed both to raise the art's status and to point the significance of his own contribution.

Whatever was commonly felt about his subject-matter, that the artist prized it must have been hard to miss after the Exhibition of 1819, at which 'The White Horse' – a canvas 51 × 73 inches – was, says his friend and biographer C.R. Leslie, 'too large to remain unnoticed'. And this was only the first in a veritable parade of vast *machines*.

Constable's manner was rarely less than freakish.

> Effect, *quocunque modo*, is the idol of Constable, both in his painting and himself, and both would be more respected with less coarseness.
>
> *Morning Chronicle*, 1830

> We have found out Mr Constable's secret, he is a Cornelius Ketel; see Harding's excellent catalogue of portraits, No. 153: 'Cornelius Ketel took it into his head to lay aside his brushes and to paint with his fingers only; and at length, finding these tools too easy, undertook to paint with his toes'.
>
> *Morning Chronicle*, 1831

Some, obviously, saw the rudeness, the unfinish (so-called) as an end in itself – the phrenetic signals of a person without much to say. According to Callcott, wrote Constable: 'I did not believe what I said, but only wished to attract attention by singularity'. Where the pictures were concerned, some did discover a way round the difficulty. As the unusually well-intentioned Charles Nodier remarked of 'The Haywain' in 1821:

> Near, it is only broad daubings of ill-laid colours which offend the touch as well as the sight, they are so coarse and uneven. At the distance of a few steps it is a picturesque country. . .

Retreat and all is well. But perhaps the point had been missed. 'The Haywain' was shown at the Paris Salon of 1824, and it was thought, so Constable noted, that

> 'as the colors were rough, they must be seen at a distance' –

Yet he goes on:

> they found their mistake as they then acknowledged the richness of the texture – and the attention to the surface of objects . . .

Even here his audience could not have gone the whole way. Constable valued rather little the occasional enthusiasm for him of the French, and he would never cross the Channel to meet his admirers.

When his handling was relatively inconspicuous Constable still did not want the observer to forget that he had before him an artefact. The prominent signature – 'Jo͞n Constable.f:1817.' – to 'Flatford Mill' (pl. 10) is at once *trompe l'oeil* – a name scored in the earth – and, since it is lit from the wrong side, illusionistic anomaly, which gives the clue to a wilful manipulation of light and shade. It is as though Constable were insisting that through the object the maker must be discerned.

The art of Constable was an art of ideas, as Leslie tersely emphasises:

> A picture of a murder sent to the Academy for exhibition while he was on the Council, was refused admittance on account of a disgusting display of blood and brains in it; but he objected still more to the wretchedness of the work, and said, 'I see no *brains* in the picture.'

What were Constable's ideas is a question which needs careful consideration. Constable accepted the grand intentions of the Academy. Art, declared Sir Joshua Reynolds in his *Discourses* (the bible of British academicism and a book pretty well committed to memory by Constable), ought to 'ennoble' and 'elevate' – the artist should 'raise the thoughts, and extend the views of the spectator': 'instead of seeking praise by deceiving the superficial sense . . . , he must strive for fame by captivating the imagination.' But Constable could not believe that Sir Joshua and his fellows understood fully how these ends were to be attained. Their insufficiently critical veneration for the heroes of the past was a hindrance. A student had no right to question the artistic models which his master set: 'If you should not admire

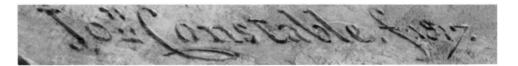

Scene on a Navigable River (Flatford Mill) 1816–17 (detail)

them at first, you will, by endeavouring to imitate them, find that the world has not been mistaken' – '*feign a relish, till wè find a relish come*', advised Reynolds. 'It appears to me', says Constable, 'that pictures have been over-valued; held up by a blind admiration as ideal things, and almost as standards by which nature is to be judged rather than the reverse'.

For the academics *high art* was the display of superior beings in the grip of 'philosophick wisdom' and 'heroick virtue' – essentially, great men at great moments (lesser creatures, even animals, were admissible so long as they trod classic ground). All other *genres*, landscape amongst them, were more or less incapable of carrying a moral burden. 'Need I mention', C.R. Leslie enquires, 'how very little Constable cared for the usual classifications of art? . . . *Good art* was with him *high art*, however humble the subject; and mediocre art, let the attempt be ever so sublime, was in his estimation, *low art*'. Such eccentricity was not welcome. Shortly before the Academy election of 1828, in which he was a candidate, Constable

> was 'pounced upon' by Mr. Shee . . . and came in for my share of castigation . . . Mr. Phillips likewise caught me by the other ear – and kicked & cuffed me most severely – I have not yet recovered. I have heard so much of the higher walks of the art, that I am quite sick. I had my own opinions even on that – but I was desired to hold my tongue . . .

On this occasion Etty took the palm and Constable may have remembered Etty's Diploma piece, 'Sleeping Nymph and Satyrs', when, the following year, he underwent

> an ordeal . . . in which 'kicks' are kind treatment to those 'insults to the mind,' which 'we candidates, *wretches* of necessity' are exposed to, annually, from some 'high-minded' members who stickle for the 'elevated & noble' walks of art – i.e. preferring the *shaggy posteriors of a Satyr* to the *moral feeling of landscape*.

From an early date Constable had encountered disdain and puzzlement. Farington records a visit of 1808: 'Constable called. – Haydon asked Him "Why He was so anxious abt. what He was doing in art?" – "Think, sd. He, what I am doing," meaning how much greater the object & the effort. –'

What, then, was Constable up to? In 1802, thinking of his role in life, he wrote: 'there is room enough for a natural painture'. The statement is a trifle opaque. Had he topography in view? Constable sent 'Englefield House' to the Academy in 1833 and

> S[hee] told me it was 'only a *picture of a house*, and ought to have been put into the Architectural Room.' I told him it was 'a picture of a summer morning, *including a house*'.

Was he, perhaps, a topographer concerned to an unusual degree with the weather?

Constable aimed to be much more.

> Painting is a science, and should be pursued as an inquiry into the laws of nature. Why, then, may not landscape painting be considered as a branch of natural philosophy, of which pictures are but the experiments?

These intriguing words were spoken at the Royal Institution in 1836, before an audience which included Michael Faraday, the foremost natural scientist of the era; indeed, Faraday seems to have put forward Constable as a lecturer. Constable's remarks should be taken seriously but just what they signify is difficult to tell. Long before, at the age of twenty-one, Constable produced as pendants 'The Chymist' and 'The Alchymist' and crude though these paintings are, they apparently play off two concepts of science: as free enquiry and as mumbo-jumbo. To the latter panel Constable attached Shakespeare's description of the alchemist's den in *Romeo and Juliet*, and that passage turns up again in one of the artist's *dicta*:

> The old rubbish of art, the musty, common place, wretched pictures which gentlemen collect, hang up, and display to their friends, may be compared to Shakespeare's
> 'Beggarly account of empty boxes,
> Alligators stuffed,' &c.
> Nature is anything but this, either in poetry, painting, or in the fields.

Constable seems to have taken to heart the teaching of Francis Bacon and his followers, and again and again his attitudes recall the New Philosophy, Bacon's programme for the reform of science. By the early nineteenth century Baconianism had become commonplace in scientific circles and had touched many disciplines other than science: in art, however, it was rare if not wholly unknown, and Constable gave it truly radical expression, with a radical's oversimplification. When he spoke out sharply against 'bravura' Constable was attacking 'The great vice of the present day', oratory for oratory's sake: 'an attempt at something beyond the truth'. On nearly every side he discovered 'manner', the repetition of established forms merely because established they were. Constable had a deep distrust of received opinions, or at any rate of their unquestioned acceptance. Much of the dogma current in his profession was, he thought, ill-founded: custom hid ignorance. The Baconians had argued, and were still arguing, along such lines. And like them Constable had a plan of action – in some sort. He wanted to begin anew from the very ground, relying on his own experience in place of secondhand learning. Go unprejudiced to nature, the 'PRIMITIVE SOURCE', Constable insists; examine what has been quite unseen, what was hitherto inconsiderable – my art, he boasts, 'is to be found under every hedge'.

> The landscape painter must walk in the fields with an humble mind. No arrogant man was ever permitted to see nature in all her beauty.

That statement is courageous (and not altogether lacking in conceit). The beauty which engrossed Constable was never the beauty of appearances in any simple sense. From a close examination of the particular were to arise comprehensive 'laws' of novel power. That the intention was to explain rather than to describe is evident. In 1823 Constable was present at the opening of the London Diorama, a display of huge transparencies, probably made from *camera obscura* images, and the illusionistic spectacle of the day: 'it is', he comments in a letter to his friend Archdeacon Fisher, 'without the pale of Art because its object is deception'. This is amplified in a letter of 1824 after a visit to Devil's Dyke, Brighton:

> It is the business of a painter not to contend with nature & put this scene (a valley filled with imagery 50 miles long) on a canvas of a few inches, but to make something out of nothing, in attempting which he must almost of necessity become poetical.

Poetry is elemental truth as opposed to mean fact. Constable the natural philosopher was in search of nature's inner life: a timeless pattern behind the vagaries of time. This was not knowledge for knowledge's sake. To Constable, as to virtually any scientist of his day, investigation of nature's workings was a religious activity: the timeless pattern was the divine scheme.

Precisely *how* generalisation was to supersede an awareness of particulars Lord Bacon, alas, was unable to relate. He implies that the process is a fairly spontaneous one if only the detail of nature be clearly grasped – and Constable echoes this at the end of the quotation above. In practice Bacon's reticence on the topic hardly made for peace of mind.

Constable's procedure does have a 'Baconian' semblance. The artist went to nature with novel enthusiasm and openness of mind. A mass of what, no doubt, he would have called record – extraordinarily vivacious reportage – is extant; with brush, pen, or crayon in hand Constable exposed himself to the English countryside. He was certainly willing to confine his gaze. What had been only incidentals, even to landscapists, now, at least momentarily, became subjects in their own right: a bit of sky, tree tops against cloud, tree and grass. Frequently Constable seems to sacrifice much for the sake of little – an exact tonal relationship, the counterpoint of foliage and clouds are caught at the expense of proportion or structure. Yet how rich truly is the reward. Before multifarious natural phenomena Constable developed a power of discrimination which has scarcely been rivalled.

For all the distinctive handling an impression of anonymity persists and that is the gauge of Constable's

success. Surely here, if anywhere, the subject dictates the mode of expression? To take Constable's studies as automatic writing is quite customary. But, of course, this is the art which art conceals. Constable cannot have been wholly unselfconscious. As his youthful essays pathetically underline, he was no born virtuoso, and any freedom was hard won. His studies are the deliberate cultivation of a new vocabulary: those scoops and whirls of paint are the means by which he got at his material and do not merely follow the event.

> 'It is the Soul that sees; the outward eyes
> Present the object, but the Mind descries.'

Precisely how well Constable grasped the wilful aspect of discovery, even late in life when he retailed Crabbe's couplet, is impossible to determine: that he knew the *innocent eye* for a myth is beyond question.

Though he valued the studies highly, for Constable the matter did not end there. 'His manner of talking', says Leslie,

> was perpetually digressive . . . His conversation might be compared to a dissected map or picture, of which the parts, as seen separately, appear to have no connection, yet each is capable of being so placed as to form a complete whole.

Constable, no doubt, hoped that in art, as in talk, some larger truth would emerge from his discursions: yet, clearly, he did not, like many of his latterday encomiasts, believe that the studies could be left to speak for themselves.

For a while Constable tried to reconcile the pressures of particular experience and the urge to deliver large statements in canvases painted more or less entirely on the spot. Leslie says 'Boat-building near Flatford Mill' (R.A. 1815) was so painted and there are one or two other medium-sized works of the period which probably were also. It was a short-lived, if heroic, attempt – the task was too complicated for fieldwork. The unfinished 'Dedham Lock and Mill' of *circa* 1817–19 (pl. 11) may have been one of Constable's last efforts of this sort, abandoned when unity was threatened by the variousness of the information Constable wanted to include.

On a larger scale Constable's problems were truly formidable. 'Flatford Mill' (pl. 10) has plenty of learning about the look of nature. There are passages of engaging freshness which would not be out of place amongst the studies, but the whole is somehow less than the sum of the parts: Constable literally could not see the wood for the trees. The painter's compositional devices are only too visible, each part of the design echoing another with assumed artlessness, and the impression, finally, is of an order imposed upon, rather than drawn from, the material.

The extent of Constable's problem is indicated by a change in his method, a move without precedent in landscape painting. For 'The White Horse' (R.A. 1819) he made a 'sketch' the same size as the *machine* itself, and he continued to produce such sketches until his last years. The suggestion has been advanced that Constable used his sketches to discharge a degree of emotion which the public would have found intolerable. But the notion that Constable in any 'finished' version bends to comtemporary taste is hardly tenable. Friends were worried about the roughness of his handling and often said so – the closest of them, Archdeacon Fisher, regretted a 'want of the hat brush & pressing iron'. When a young man Constable was truculent, and there are numerous signs that he appreciated what would make him more acceptable but refused to toe the line. As the years went by he became markedly indisposed to make concessions.

The trouble, actually, was that Constable knew a great deal about, for instance, cloud forms at 4.30 pm on a windy day in the Summer of 1821: and he knew a lot about the coloration of foliage on a Spring morning in 1810. But how everything looked at a specific moment, let alone how everything looked all the time, he did not know. Constable's difficulty was to correlate his observations, and this difficulty the sketches were to meet. To be a 'natural painture' was far from easy.

Constable *wanted* to work independently of models. In

1833 the collector William Wells paid a call:

> He saw hundreds of my things – I sincerely beleive nothing amongst them made any impression upon him or did they come into his rules, or whims, of the art. I told him, that I had perhaps other notions of the art than picture admirers in general – I looked on *pictures* as things to be *avoided* – Connoisseurs looked on them as things to be *imitated*, & this too with a deference and humbleness of submission amounting to a total prostration of mind, & original feeling, that must obliterate all future attempts - and serve only to fill the world with abortions.

In fact he had a wide knowledge of pictures. The sale after his death included almost sixty paintings by 'Old and Modern Masters' ranging from Lucas Cranach through Teniers and Wilson to John Jackson, R.A. and a number more had been disposed of earlier. He owned many drawings and over 5000 prints. And he was no stranger to the great private collections. He could be vigorously critical of what he saw – a whole bundle of Claude's drawings 'looked just like papers used and otherwise mauled, & purloined from a Water Closet'. But he was often positively rapturous – and about Claude: his praise of Titian, Rubens, and Rembrandt was extreme. Copying was a life-long activity, not solely youthful exercise and on occasion, positively abnegating self, he was ready to make a 'facsimile'. In 1823 during a veritable orgy of picture worship at Sir George Beaumont's house, where he 'slept with one of the Claudes every night', Constable wrote to his wife

> I do not wonder at your being jealous of Claude if any thing could come between our love it is him. but I am fast advancing a beautifull little copy. of his Study from Nature of a little grove scene which will be of service to me for life.

So late as 1832 he copied a Ruisdael in Sir Robert Peel's collection. But Constable could learn from humbler specimens and he made copies of, for example, Beaumont's drawings – even those of Dedham, his own territory.

For Constable the study of others and the production of his own work were closely connected. He was aware, though he often chose to forget, that art owes at least as much to art as to anything else, that it is 'a plant of the conservatory, not of the desert'.

> I remember [relates C.R. Leslie] to have heard him say, 'When I sit down to make a sketch from nature, the first thing I try to do is, *to forget that I have ever seen a picture*.'

And yet

> He well knew that, in spite of this endeavour, his knowledge of pictures had its influence on every touch of his pencil, for in speaking of a young artist who boasted that he had never studied the works of others, he said, 'After all there *is* such a thing as the art.'

During 1806 Constable visited the Lake District in which he was really a 'foreigner'. Here, if anywhere, an untutored response might have been expected: but his mind was no *tabula rasa*. A watercolour of Borrowdale is annotated:

> . . . fine clouday day tone very mellow like – the mildest of Gaspar Poussin and Sir G[eorge] B[eaumont] & on the whole deeper than this drawing –.

And of course what he measured against other artists was itself in part a product of their example. When he fancied he saw 'Gainsborough in every hedge and hollow tree' Constable was thinking of the early and comparatively self-effacing landscapes such as the so-called 'View of Dedham' (Tate Gallery). But Gainsborough was usually a rhetorician, not a reporter: as Constable said, 'With particulars he had nothing to do; his object was to deliver a fine sentence.' And Constable was prepared to utilise him at his most factitious. There are drawings and at least one painting clearly derived from those works which, as any reader of Reynolds's *Discourses* must have known, Gainsborough cooked up from dried herbs, broken glass and lumps of stone in a candle-lit studio.

Constable took these recipes into the countryside. 'At all times of the day, at night, and in all seasons of the year,' wrote George Field,

> Constable had inexpressible delight in viewing the works of nature. I have been out with him after all colour of the

landscape had disappeared and objects were seen only as skeletons and masses, yet his eye was still active for his art. 'These were the things,' said he, 'that Gainsborough studied, and of which we have so many exquisite specimens in his drawings.'

It looks as though Constable were deliberately reading nature in terms of art. From Gainsborough, perhaps more than from anyone else, came a repertory of simple shapes. Constable needed to see broadly before he could deal with nature in fine.

Instances of the give and take between art and nature are not far to seek. Even Constable's most striking innovations did not come out of the air. About 1785 Alexander Cozens published *A New Method of Assisting the Invention in Drawing Original Compositions of Landscape.* Cozens was no ordinary drawing master. He accepted that the artist needs to stock his mind with the images of art, needs to work from patterns. To the treatise engravings of sky types were appended, and there is a touchingly awkward set of drawings after these by Constable. But Cozens knew also that an imaginative effort must be made, not merely waited upon. The artist, he suggests, should push his patterns below the surface of the mind and make semi-random doodles or 'blots': whereupon new combinations will manifest themselves. Why this should happen Cozens could not tell. He offers no rational act but a magic ritual. There are indications that Constable was, at any rate occasionally, Cozensish: there are several ink-wash drawings by him of a blottish character. Of course, Cozens's goal was fantasy whereas Constable was after the 'real' (the designation of Cozens's son John Robert as 'all poetry' is surely not unmixed praise). The 'Cloud Study' (pl. 19) shows to what length a hint from Cozens might be taken. *Schemata* have become supremely subtle notations, and the brief commentaries with which such studies were often supplied emphasise the move on from Cozens:

Sepr. 5. 1822. looking S.E. noon. Wind very brisk. & effect bright & fresh. Clouds. moving very fast. with occasional very bright openings to the blue.

Sepr. 12. 1821. Noon. Wind fresh at West . . . Sun very Hot. looking southward exceedingly bright vivid & Glowing, very heavy showers in the Afternoon but a fine evening. High wind in the night.

And so on. Shapes, colours, tones, textures are without intrinsic significance: they are the traces of a great dynamic process, living nature.

Possibly Constable remembered Cozens when he devised the large 'sketch'. In this he overrides the minute discrimination of the studies and tries to treat his entire repertory with equal favour: each part is done with brushes of the same size, the same sort of touch. And he may have hoped that, willy-nilly, an inner harmony would assert itself.

Painting was no simple business. Whatever his pretensions to scientific detachment, there was nothing dispassionate about Constable's art: 'Painting', he once wrote, 'is but another word for feeling'. He was, Leslie remarks,

peculiarly social and could not feel satisfied with scenery, however grand in itself, that did not abound in human associations. He required villages, churches, farmhouses, and cottages.

'One thing is striking', observes Leslie of the sketchbooks,

which may be equally noticed of his pictures, that the subjects of his works form a history of his affections.

Above all he felt deeply for his native Suffolk.

I associate my 'careless boyhood' to all that lies on the banks of the *Stour*. They made me a painter (& I am gratefull) that is I had often thought of pictures of them before I had ever touched a pencil . . .

The same places 'witnessed by far the most affecting event of my life', courtship of and engagement to Maria Bicknell. And when her family's opposition delayed their marriage for several years, the scenes of boyhood acquired a new shade of meaning. 'From the window . . . I see all those sweet feilds', he wrote to her from Bergholt in 1812,

where we have passed so many happy hours together – it is with a melancholy pleasure that I revisit those scenes that once saw us so happy . . .

Their trials encouraged the idea of nature as a refuge. Bergholt became 'that dear spot' to which Constable could turn 'as a safe and calm retreat'. In 1814 he quoted to Maria the Rev. Archibald Alison on nature as the

'one gentle and unreproaching friend – whose voice is ever in alliance with goodness and virtue – and who is alone able to sooth misfortune'.

Nature could reassure in this way because it revealed the hand of God –

the hand that has, with such lavish beneficience, scattered the principles of beauty and happiness throughout every department of the Creation.

In fields and under bushes the Deity may have come upon the young painter more violently than was the rule – legend has Constable overwhelm a local girl with the argument 'God gave me a job to do and you are here to help me'. But the idea of natural Revelation was not exclusive to Constable. He was unwilling to recognise the effect of literature upon the way he looked at nature; one of his reasons for admiring Cowper was that he 'numbered it among his advantages as a composer that he had read so little poetry'. Yet Constable referred his public to literature on several occasions. In the catalogues of the Academy and the British Institution he quoted Thomson, Gray, Bloomfield and Coxe, and he intended to gloss the mezzotints in *English Landscape* with passages from a variety of poets. The idea of a nature friendly to man, man in consonance with nature, is a leading theme in the eighteenth century and Constable was fairly well-versed in its literature. And his taste was not just for unaffected description, simple strains. He sought out landscape references in much earlier poetry and was especially impressed by the grandiose Milton.

But Constable had an attachment to particular places which was new in the later 1700s. His friend Fisher saw him as a sort of Gilbert White:

I am reading for the third time White's history of Selbourne. It is a book that would delight you & be highly instructive to you in your art if you are not already acquainted with it. White was the clergyman of the Place & occupied himself with narrowly observing & noting down all the natural occurrences that came within his view : and this for a number of years . . . it is in your own way of close natural observation . . .

Constable agreed : 'This book is an addition to my estate'.

In the poetry of Constable's day landscape bore an increasingly heavy emotional load. Constable's mentor Sir George Beaumont was poetaster as well as painter and his circle included Wordsworth and Coleridge, *the* new poets. Wordsworth has often been brought in to explain what Constable was about and there are, indeed, parallels. For Wordsworth, avowedly, experience of the countryside was relevant – was, indeed, vital – to man's make-up at all levels. He eschewed elaborate language and extravagant subjects, yet his ambitions were sizeable enough. He chose 'incidents and situations from common life' but with the aim of tracing 'the primary laws of our nature', for in that rustic condition 'the passions of men are incorporated with the beautiful and permanent forms' of the natural world. The humble life, meadows and mountains, were somehow or other to yield up divinity.

WISDOM and Spirit of the universe !
Thou Soul, that art the Eternity of thought !
And giv'st to forms and images a breath
And everlasting motion ! not in vain,
By day or star-light, thus from my first dawn
Of childhood didst thou intertwine for me
The passions that build up our human soul ;
Not with the mean and vulgar works of Man ;
But with high objects, with enduring things,
With life and nature ; purifying thus
The elements of feeling and of thought,
And sanctifying by such discipline
Both pain and fear, – until we recognise
A grandeur in the beatings of the heart.
Influence of Natural Objects in calling forth and strengthening the imagination in Boyhood and early Youth, ll. 1–14.

Every tree seems full of blossom of some kind & the surface of the ground seem[s] quite living – every step I take & on whatever object I turn my Eye that sublime expression in the Scripture 'I am the resurrection & the life' &c seems verified about me –.

This observation was made by Wordsworth, on a Spring walk, to Constable, who passed it off as his own in a letter to his wife. Wordsworth's 'pain and fear', however, lost their edge quite early on and tranquillity prevailed, but Constable was not always so comfortable.

In some respects Constable is closer to the dark figure of Coleridge than to any other poet. They both have, as Wordsworth does not, a sense of the specific character of natural phenomena, an acute awareness of time and place: the entries in Coleridge's notebooks often strikingly recall the painter. Constable, who thought that there were some pretty descriptions in *The Excursion*, may well have fallen in with Coleridge's suggestion that Wordsworth too rarely penetrated 'the superficies of Objects':

Never to see or describe any interesting appearance in nature without connecting it, by dim analogies, with the moral world proves faintness of impression. Nature has her proper interest, and he will know what it is who believes and feels that everything has a life of its own, and that we are all *One Life*. A poet's heart and intellect should be *combined*, intimately combined and unified with the great appearances of nature, and not merely held in solution and loose mixture with them, in the shape of formal similes.

A complete identification of mental states with moods of nature was what Constable admired in Coleridge. He was pleased that the French thought his pictures like

the full harmonious warblings of the Aeolian lyre, which *mean* nothing. . . . Is not some of this *blame* the highest *praise* – what is poetry? – What is Coleridges Ancient Mariner (the very best modern poem) but something like this?

The 'Aeolian lyre' was a type of harp which sounded when the wind blew across the strings. But if both Coleridge and Constable wanted to see themselves as passive instruments of nature's voice, neither could do so

for long. Coleridge, like his Mariner, got out of tune with the natural world. The demands he made of his art were complex, perhaps exorbitant, and a note of desperation is frequently heard in his appeal to nature.

For many, in fact, to draw comfort from nature was becoming difficult, while the need of comfort intensified. The half century or so from 1785 was probably the period of greatest strain in the English economy's shift from agriculture to industry. Techniques of farming improved, and at speed, but the cost of improvement was high: more efficient planning and mechanisation led to massive unemployment. The shadow of a countryside unsettled lay over the art of pastoral. The Peasant Poet John Clare plaintively wrote:

Now this sweet vision of my boyish hours
Free as spring clouds and wild as summer flowers
Is faded all – a hope that blossomed free
And hath been once no more shall ever be
Inclosure came and trampled on the grave
Of labours rights and left the poor a slave
And memorys pride ere want to wealth did bow
Is both the shadow and the substance now
The Mores, ll. 15–22

For Clare the masters had sold out and it was their greed which had destroyed the old order: with enclosure the peasantry were dispossessed. But those who had profited most from the peasants' loss felt the pinch in their turn. Even where the stress of enclosure had passed, matters could be very bad. Suffolk was perhaps the saddest case. Suffolk was in many respects the most highly organised of English farming areas and during the agricultural depression which followed the wars with France suffered more acutely than most. Major Edward Moor of Great Bealings reported to the Board of Agriculture in 1816:

As a magistrate for this county, heretofore so wealthy and happy, no day, scarcely no hour of any day passes, without some occurrence bringing before me some instance of agricultural distress.

And he is talking no less about the farmers than about the labouring classes. The balance of rural life was every-

where affected. Constable was not blind to this. 'My brother is uncomfortable about the state of things in Suffolk', he told Fisher in 1822,

> They are as bad as Ireland – 'never a night without seeing fires near or at a distance', The *Rector* & his brother the *Squire* . . . have forsaken the village . . .

The threat of political change which would give to a disaffected populace a growing part in the running of the country was to many a source of anxiety. Archdeacon Fisher feared for the Church, the very pivot of English life:

> The vulture of reform is now turning its eyes on the Church & is preparing to fix his talons in her fat . . . The liberal, literary, & learned body to which I unworthily belong, will disappear: the universities will be converted into charitable seminaries, & the illiterate offspring of grocers & tallow chandlers will fill the pulpits.

Constable made soothing sounds to Fisher but himself reacted violently to 'reform'. To him the Reform Bill of 1832 was the instrument of wholesale anarchy, a 'tremendous attack on the constitution of the country' which would

> give the government into the hands of the rabble and dregs of the people, and the devil's agents on earth – the agitators.

Indeed, life got no easier for Constable. He really had not the temperament of a Gilbert White, nor even Wordsworth's complacency and he could not feel that sunshine would follow every storm. Leslie noted 'how far his mind was from being an equable one'. He became increasingly 'a prey to melancholy and anxious thoughts'.

The idyllic picture which Constable himself gives of his childhood and youth is almost too good to be true. At any rate, after the deaths of his mother, in 1815, and his father, in 1816, he became more and more a willing exile from the halcyon scenes. During 1816 he married, but domestic bliss was soon overshadowed. Having produced seven children in twelve years, Maria died at the age of forty-one from pulmonary tuberculosis.

Hourly do I feel the loss of my departed Angel. God only knows how my children will be brought up. Nothing can supply the loss of such a devoted, sensible, industrious, religious mother, who was all affection. But I cannot trust myself on that subject. I shall never feel again as I have felt, the face of the World is totally changed to me . . .

Personal troubles may reasonably be thought to have affected Constable's painting. The 'face of the World' had already begun to change for him before Maria's death. Placidity gave way in the 1820s to a consciousness of nature's animation, which at first was welcome. 'I have likewise made many *skies* and effects –', he wrote to Fisher in 1821,

> for I wish it could be said of me as Fuselli says of Rembrandt, 'he followed nature in her calmest abodes and could pluck a flower on every hedge – yet he was born to cast a stedfast eye on the bolder phenomena of nature'.

No artist was ever more involved with the movement of nature than is Constable in such paintings as 'The Gleaners, Brighton' (pl. 21). He seems confident of his ability to manage the changeful scene.

> In some of these subjects of Landscape an attempt has been made to arrest the more abrupt and transient appearance of the CHIAR' OSCURO IN NATURE; to shew its effect in the most striking manner, to give 'to one brief moment caught from fleeting time,' a lasting and sober existence, and to render permanent many of those splendid but evanescent Exhibitions, which are ever occurring in the endless varieties of Nature, in her external changes.
>
> Introduction, *English Landscape*, 1833

It might be thought from what he says about the sea that Constable was deeply interested in such effects:

> Of all the works of the Creation none is so imposing as the Ocean; nor does Nature anywhere present a scene that is more exhilarating than a sea-beach, or one so replete with interesting material to fill the canvass of the Painter; the continual change and ever-varying aspect of its surface always suggesting the most impressive and agreeable sentiments . . .
>
> Letterpress, *English Landscape*

Yet the sea plays a rather minor rôle in the 'marine

subjects' (witness 'The Sea near Brighton', pl. 23) and one may guess that its 'ever-varying aspect' was beyond him.

By the date of those remarks in *English Landscape* Constable's connection with the 'PRIMITIVE SOURCE' was somewhat tenuous. The 'natural painter' was losing sight of nature. '*I never saw an ugly thing in my life*', said Constable, but as the years went by he tended to avert his eyes. He wrote to Fisher from Brighton in 1824:

> The magnificence of the sea, and its (to use your own beautifull expression) everlasting voice, is drowned in the din & lost in the tumult of stage coaches . . . and the beach is only Piccadilly . . . by the sea-side. Ladies dressed & *undressed* – gentlemen in morning gowns & slippers on, or without them altogether about *knee deep* in the breakers – footmen – children – nursery maids, dogs, boys, fishermen – *preventive service men* (with hangers & pistols), rotten fish & those hideous amphibious animals the old bathing women . . . – all are mixed up together in endless & indecent confusion. The genteeler part, the marine parade, is still more unnatural – with its trimmed and neat appearance & the dandy jetty or chain pier. . . . In short there is nothing here for a painter but the breakers – & sky – which have been lovely indeed and always varying.

The natural and the artificial are here diametrically opposed. That such an antithesis underlies 'Chain Pier, Brighton' (pl. 24) may be suspected, but suspected only. Despite occasional felicities of touch (those delicious bathing machines, for instance), the picture is patently a studio construction.

From the later 1820s Constable virtually ceased to paint from nature. The studies of earlier days were taken up and set pieces reworked. 'The Glebe Farm' of *c*.1830 (pl. 28) was based on a picture exhibited in 1827, itself derived from an oil study made about 1810. Attachment to locality was so far weakened that in *English Landscape* Glebe Farm was transformed into Castle Acre Priory.

Freshness of touch became a rarity. Constable could not leave his pictures alone and some were worked at over a lengthy period. The subject of 'Waterloo Bridge' employed him on and off for about fifteen years and the painting itself took more than seven. The full-size sketch was devised to meet real problems, but whether it was entirely successful may be doubted. The sketch for 'Hadleigh Castle' (pl. 25) is a battle ground – the little herd of cows, glimpsed through a maelstrom of paint, is a poignant reminder of how far behind was Gainsboroughian pastoral now. A conviction that the savage handling, the ferocious knifework, betray a fundamental uncertainty is hard to avoid. In the *machine* (Yale Center for British Art) Constable's battle is for the present over, but not won. 'every gleam of sunshine [is] blighted to me', wrote the fifty-nine year old Constable, 'in the art at least. Can it therefore be wondered at that I paint continual storms?' His storms were within.

'The Valley Farm' (pl. 30) is the summation of a lifetime's work and a sinister object it is. Constable's concern with the subject goes back to the turn of the century. And the picture bears all the marks of obsession. Constable describes himself in the studio at night – 'Oiling out, making out, polishing, scraping, &c'. He painted, rubbed down, and painted again, literally torturing the picture surface. Of colour, so long regarded by Constable as his especial strength, there is scarcely a trace (what would he have said now to Sir George's question, where do you put your brown tree?). Willy Lott's Cottage was to him the emblem of the natural life, of man and nature in concord. But the idyll is fading. That silent couple in the boat going nowhere, those cows half sunk in stagnant water, they are creatures in a bad, bad dream.

Constable's public failure was very real to him. 'I have just received a commission', he told Leslie in 1829,

> to paint a '*Mermaid*' – for a '*sign*' on an inn in Warwickshire. This is encouraging – and affords no small solace to my previous labours at landscape for the last twenty years . . .

His election as R.A. a few weeks later came twenty-seven years after his first exhibit at the Academy. And even then the President, according to Leslie,

considered him peculiarly fortunate in being chosen an Academician at a time when there were historical painters of great merit on the list of candidates.

He remained on the establishment's fringe. In its account of the Pennell *versus* Woodburn case of 1835, when he gave evidence on the authenticity of a Claude, *The Times* described Constable as 'an amateur painter'; Top People thought little of him.

He became profoundly pessimistic, doubtful of his art, dubious about art itself. 'From his first start in life', wrote Henry Trimmer,

> he was always making some great preparation to render himself worthy of notice; a point from which in his own eyes he seemed always receding. He seemed to think his works would never live; and very few of his brother artists' either.

The book *English Landscape* was conceived around 1829 to meet in some measure neglect and misunderstanding of the paintings. Constable wanted to make available to the public at large an epitome of his achievement and he put together a lengthy explanatory text. The scheme was virtually still-born. About one of the plates he wrote to his engraver David Lucas:

> I have added a 'Ruin' to the little Glebe Farm – for, *not* to have a symbol in the book of myself, and of the 'Work' which I have projected, would be missing the opportunity.

A final course remained to him: in 1834 Wilkie heard

> of a sad freak with which I have been long 'possessed' of feeling a *duty – on my part – to tell* the world that there is such a thing as landscape existing with 'Art' – as I have in so great measure failed to '*show*' the world that it is possible to accomplish it.

Though he disliked performing in public, Constable gave sets of lectures at the Hampstead Literary and Scientific Society (1833, 1835 and 1836), the Worcester Literary and Scientific Institution (1835) and the Royal Institution (1836). At the Royal Institution his four 'sermons' had, as the Index carefully notes, an average attendance of 233.2, which was certainly the largest audience he had ever enjoyed. But there appear to have been no last minute conversions of a kind which would have satisfied the painter. As always, the band of those who could both sympathise and comprehend was pitifully small.

'In the coach yesterday coming from Suffolk', wrote Constable to Lucas in 1832,

> were two gentlemen and myself all strangers to each other. In passing through the valley about Dedham, one of them remarked to me – on my saying it was beautiful – 'Yes Sir – this is *Constable's* country!' I then told him who I was lest he should spoil it.

How should that gentleman 'spoil it'? By showing he had not understood?

Further Reading

C.R. Leslie, *Memoirs of the Life of John Constable, Esq., R.A.,* 1843; revised edition, 1845; ed. J.H. Mayne, 1951.

Graham Reynolds, *Victoria and Albert Museum, Catalogue of the Constable Collection,* 1960; revised edition, 1973

R.B. Beckett, *John Constable's Correspondence,* 6 vols, 1962–8; *John Constable's Discourses,* 1970; L. Parris, C. Shields, I. Fleming-Williams, *John Constable: Further Documents and Correspondence,* 1975.

Graham Reynolds, *Constable, The Natural Painter,* 1965.

L. Parris, I. Fleming-Williams, C. Shields, *Constable: Paintings, Watercolours & Drawings,* 1976 (catalogue of the bicentenary exhibition at the Tate Gallery).

Ian Fleming-Williams, *Constable Landscape Watercolours & Drawings,* 1976.

Robert Hoozee, *L'opera completa di Constable,* 1979.

Leslie Parris, *The Tate Gallery Constable Collection,* 1981.

I. Fleming-Williams and L. Parris, *The Discovery of Constable,* 1984.

Graham Reynolds, *The Later Paintings and Drawings of John Constable,* 1984.

List of Plates

Cover
Scene on a Navigable River (Flatford Mill)
1816–17 (detail)
Canvas, 40 × 50 (1017 × 1270) [N 01273]

Frontispiece
Self-Portrait 1806
Pencil, $7\frac{1}{2}$ × $5\frac{11}{16}$ (190 × 145) on paper,
$9\frac{5}{16}$ × $5\frac{11}{16}$ (237 × 145) [T 03899]

1 *View at Epsom* 1809
Board, $11\frac{3}{4}$ × $14\frac{1}{8}$ (299 × 359) [N 01818]

2 *Malvern Hall, Warwickshire* 1809
Canvas, $20\frac{1}{4}$ × $30\frac{1}{4}$ (515 × 769) [N 02653]

3 *The Church Porch, East Bergholt* exh.1810
Canvas, $17\frac{1}{2}$ × $14\frac{1}{8}$ (445 × 359) [N 01245]

4 *Dedham from near Gun Hill, Langham* c.1810
Paper on canvas, $9\frac{7}{8}$ × 12 (251 × 305)
[N 01822]

5 *The Mill Stream* c.1810
Board, $8\frac{3}{16}$ × $11\frac{1}{2}$ (208 × 292) [N 01816]

6 *A Lane near Flatford (?)* c.1810–11
Paper on canvas, 8 × $11\frac{15}{16}$ (203 × 303)
[N 01821]

7 *Dedham from Langham* ?1813
Canvas, $5\frac{3}{8}$ × $7\frac{1}{2}$ (137 × 190) [N 02654]

8 *Brightwell Church and Village* 1815
Panel, $6\frac{1}{8}$ × 9 (155 × 228) [T 03121]

9 *Maria Bicknell, Mrs John Constable* 1816
Canvas, $11\frac{15}{16}$ × $9\frac{7}{8}$ (303 × 251) [N 02655]

10 *Scene on a Navigable River (Flatford Mill)*
1816–17
Canvas, 40 × 50 (1017 × 1270) [N 01273]

11 *Dedham Lock and Mill* c.1817–19
Canvas, $21\frac{1}{2}$ × $30\frac{1}{8}$ (546 × 765) [N 02661]

12 *Harwich Lighthouse* ? exh.1820
Canvas, $12\frac{7}{8}$ × $19\frac{3}{4}$ (327 × 502) [N 01276]

13 *Dedham Lock* c.1820
Paper on panel, $6\frac{1}{2}$ × 10 (165 × 254)
[N 01820]

14 *Maria Constable with Two of her Children* c.1820
Panel, $6\frac{1}{2}$ × $8\frac{11}{16}$ (166 × 221) [T 03903]

15 *Hampstead Heath, with the House Called 'The Salt
Box'* c.1820
Canvas, $15\frac{1}{8}$ × $26\frac{5}{16}$ (384 × 668) [N 01236]

16 *Hampstead Heath, with Harrow in the Distance*
c.1820–2
Paper on canvas, $6\frac{11}{16}$ × $12\frac{5}{16}$ (170 × 313)
[N 01237]

17 *A Bank on Hampstead Heath* c.1820–2
Canvas, $8\frac{1}{8}$ × $9\frac{15}{16}$ (206 × 253) [N 02658]

18 *The Grove, Hampstead* c.1821–2
Canvas on board, 14 × $11\frac{7}{8}$ (356 × 302)
[N 01246]

19 *Cloud Study* 1822
Paper on board, $18\frac{11}{16}$ × $22\frac{5}{8}$ (475 × 575)
[N 06065]

20 *Gillingham Bridge, Dorset* 1823
Canvas, $12\frac{5}{8}$ × $20\frac{1}{4}$ (321 × 515) [N 01244]

21 *The Gleaners, Brighton* 1824
Paper on canvas, $6\frac{1}{4} \times 11\frac{7}{8}$ (159 × 302)
[N 01817]

22 *Branch Hill Pond, Hampstead Heath, with a Boy Sitting on a Bank* c.1825
Canvas, $13\frac{1}{8} \times 19\frac{3}{4}$ (333 × 502) [N 01813]

23 *The Sea near Brighton* 1826
Paper on card, $6\frac{13}{16} \times 9\frac{3}{8}$ (173 × 238)
[N 02656]

24 *Chain Pier, Brighton* 1826–7
Canvas, 50×72 (1270 × 1830) [N 05957]

25 *Sketch for 'Hadleigh Castle'* c.1828–9
Canvas, $48\frac{1}{4} \times 65\frac{7}{8}$ (1225 × 1674) [N 04810]

26 *Harnham Ridge, Salisbury* 1820 or 1829
Paper, $4\frac{1}{2} \times 9\frac{5}{16}$ (114 × 237) [N 01824]

27 *Salisbury Cathedral from the Meadows* c.1830
Canvas, $14\frac{3}{8} \times 20\frac{1}{8}$ (365 × 511) [N 01814]

28 *The Glebe Farm* c.1830
Canvas, $25\frac{1}{2} \times 37\frac{5}{8}$ (648 × 956) [N 01274]

29 *Cloud Study with Verses from Bloomfield* 1830s
Ink, $13\frac{3}{16} \times 8\frac{5}{16}$ (335 × 211) including verses
[T 01940]

30 *The Valley Farm* exh.1835
Canvas, $58 \times 49\frac{1}{4}$ (1473 × 1251) [N 00327]

31 *Hampstead Heath with a Rainbow* 1836
Canvas, 20×30 (508 × 762) [N 01275]

Note
The dimensions are given in inches followed by millimetres in brackets; height precedes width.

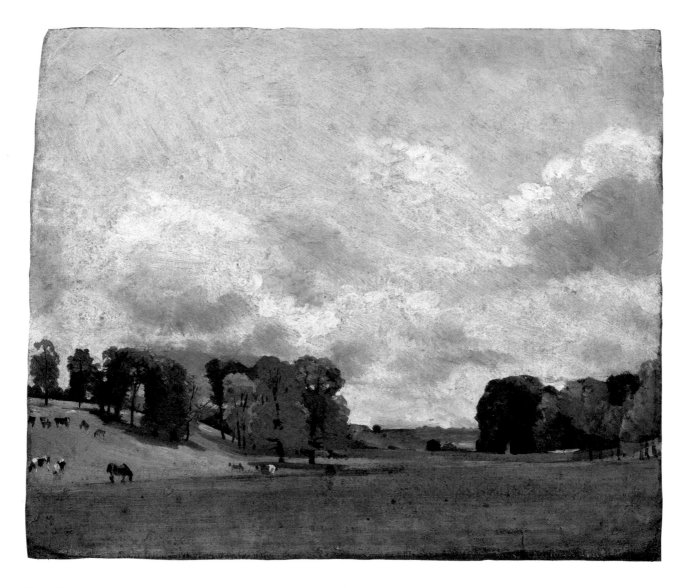

1 *View at Epsom* 1809
 Board, $11\frac{3}{4} \times 14\frac{1}{8}$ (299 × 359)
 [N 01818]

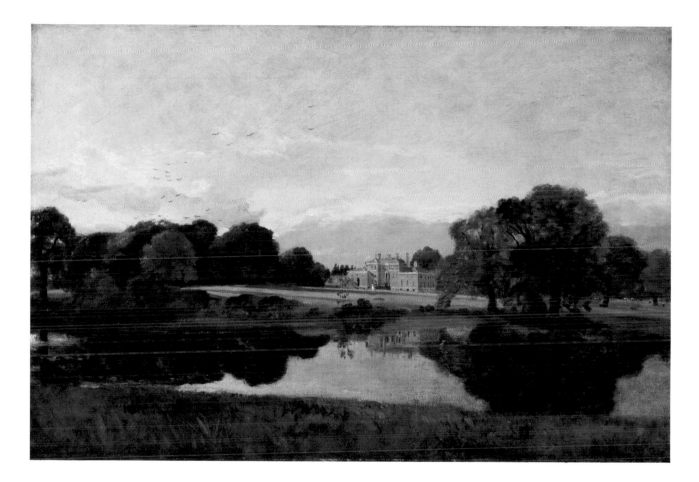

2 *Malvern Hall, Warwickshire* 1809
 Canvas, $20\frac{1}{4} \times 30\frac{1}{4}$ (515 × 769)
 [N 02653]

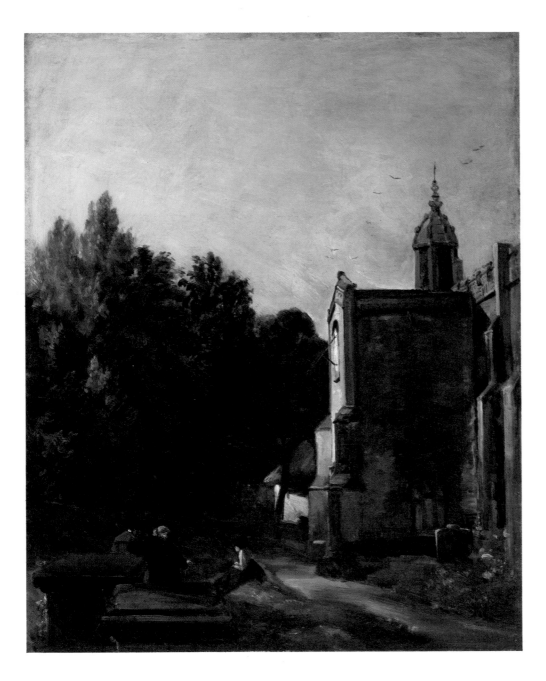

3 *The Church Porch,*
East Bergholt exh.1810
Canvas, $17\frac{1}{2} \times 14\frac{1}{8}$
(445×359) [N 01245]

4 *Dedham from near Gun Hill,*
 *Langham c.*1810
 Paper on canvas, $9\frac{7}{8} \times 12$
 (251×305) [N 01822]

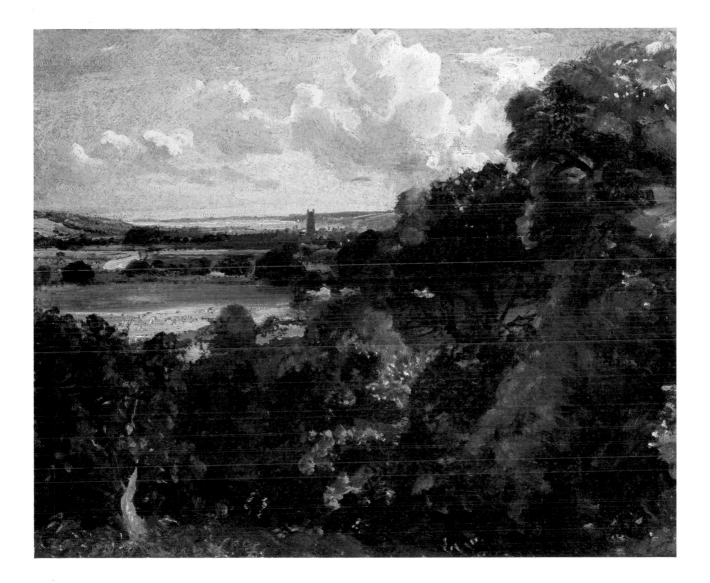

5 *The Mill Stream* c.1810
 Board, $8\frac{3}{16} \times 11\frac{1}{2}$ (208 × 292)
 [N 01816]

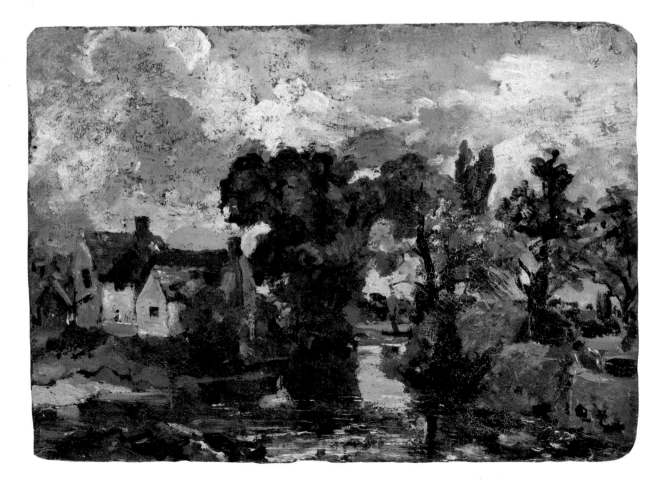

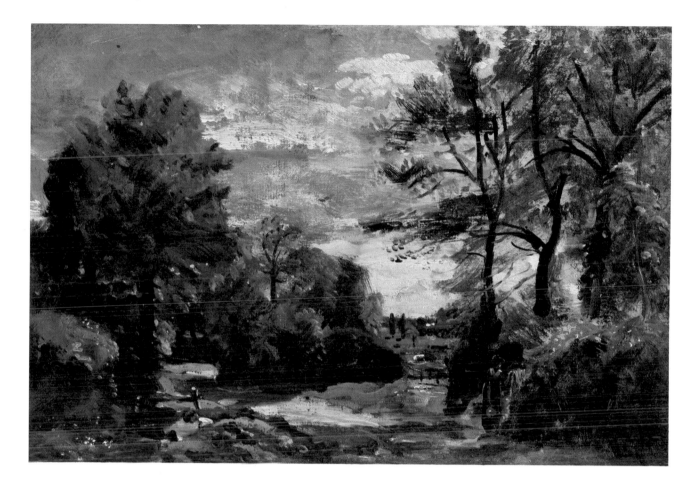

6 *A Lane near Flatford (?)* *c.*1810–11
 Paper on canvas, 8 × 11$\frac{15}{16}$ (203 × 303)
 [N 01821]

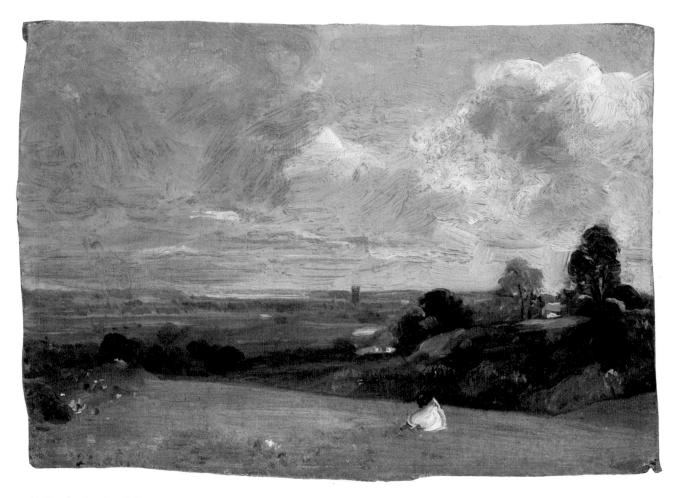

7 *Dedham from Langham* ?1813
 Canvas, $5\frac{3}{8} \times 7\frac{1}{2}$ (137 × 190)
 [N 02654]

8 *Brightwell Church and Village* 1815
Panel, $6\frac{1}{8} \times 9$ (155×228)
[T 03121]

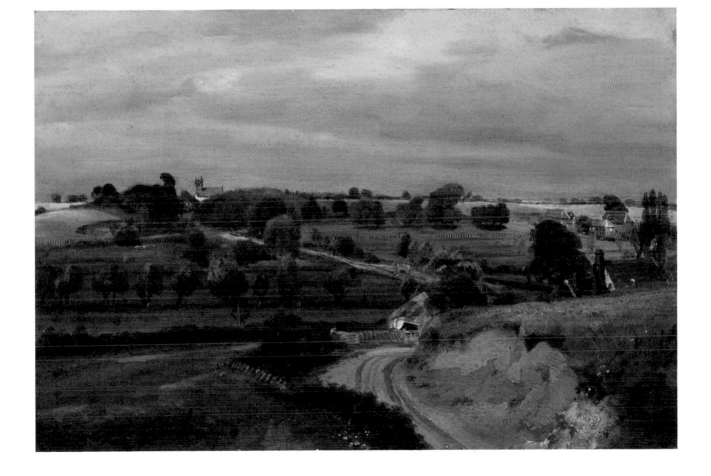

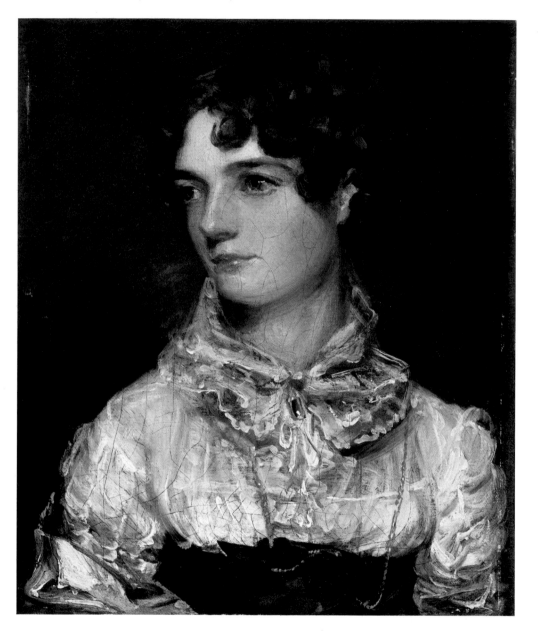

9 *Maria Bicknell, Mrs John Constable* 1816
Canvas, $11\frac{15}{16} \times 9\frac{7}{8}$
(303 × 251) [N 02655]

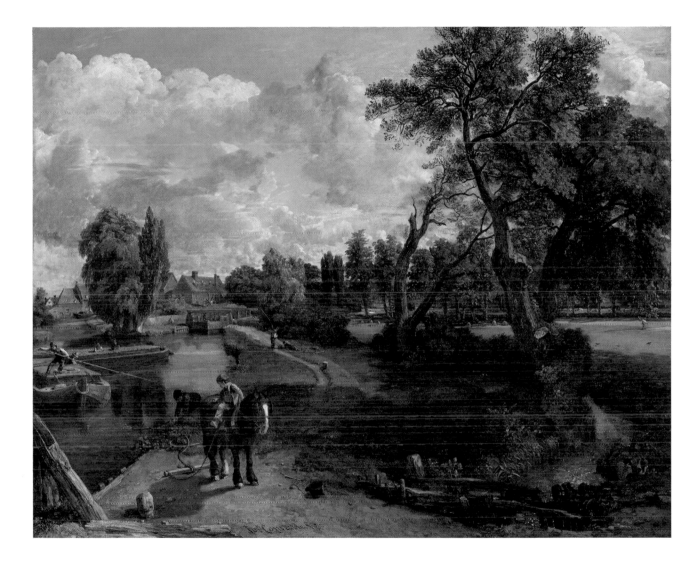

10 *Scene on a Navigable River*
 (Flatford Mill) 1816–17
 Canvas, 40 × 50 (1017 × 1270)
 [N 01273]

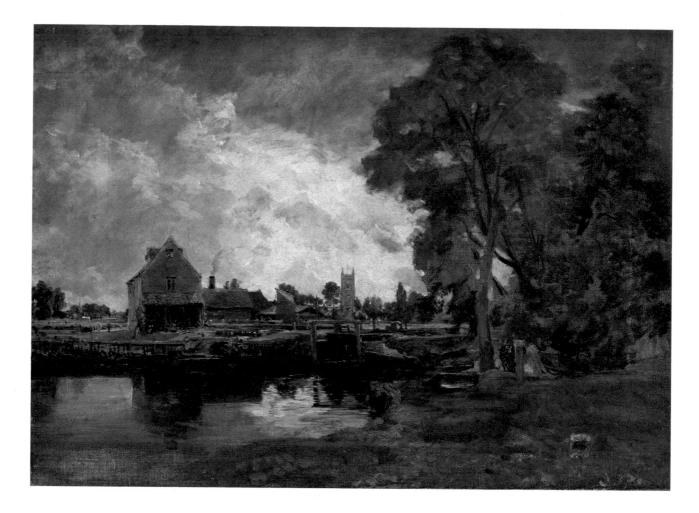

11 *Dedham Lock and Mill* *c*.1817–19
Canvas, $21\frac{1}{2} \times 30\frac{1}{8}$ (546 × 765)
[N 02661]

12 *Harwich Lighthouse* ? exh.1820
 Canvas, $12\frac{7}{8} \times 19\frac{3}{4}$ (327×502)
 [N 01276]

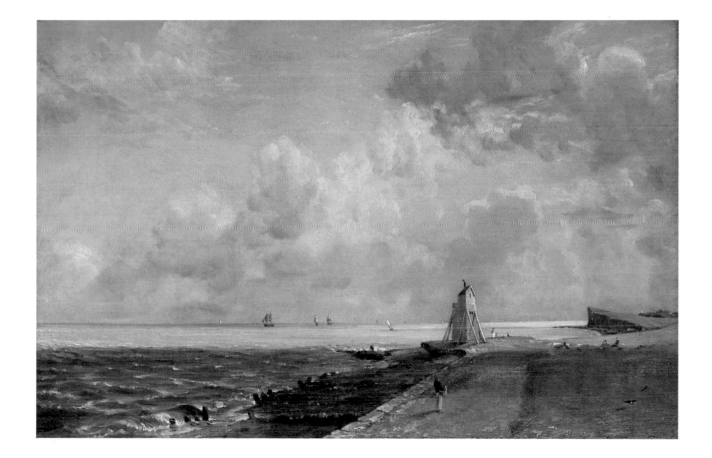

13 *Dedham Lock* c.1820
Paper on panel, 6½ × 10 (165 × 254)
[N 01820]

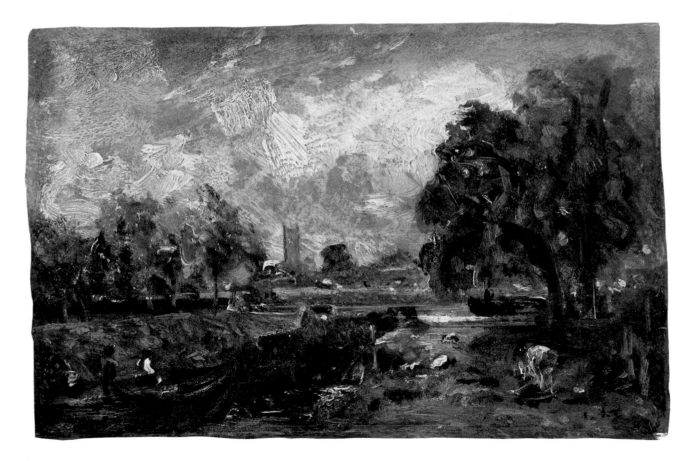

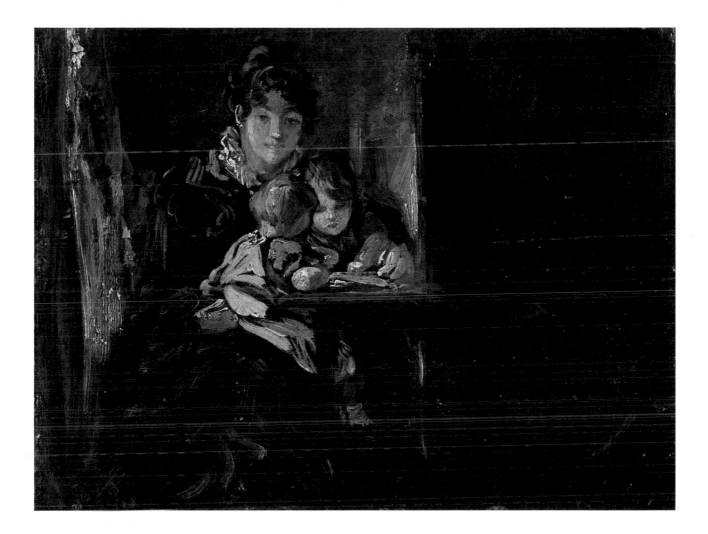

14 *Maria Constable with Two of
her Children c.*1820
Panel, $6\frac{1}{2} \times 8\frac{11}{16}$ (166 × 221)
[T 03903]

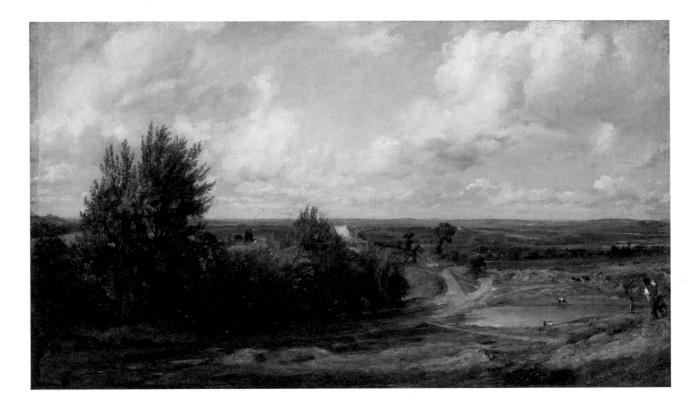

15 *Hampstead Heath, with the House Called*
 'The Salt Box' c.1820
 Canvas, $15\frac{1}{8} \times 26\frac{5}{16}$ (384 × 668)
 [N 01236]

16 *Hampstead Heath, with Harrow in the*
 Distance c.1820–2
 Paper on canvas, $6\frac{11}{16} \times 12\frac{5}{16}$ (170 × 313)
 [N 01237]

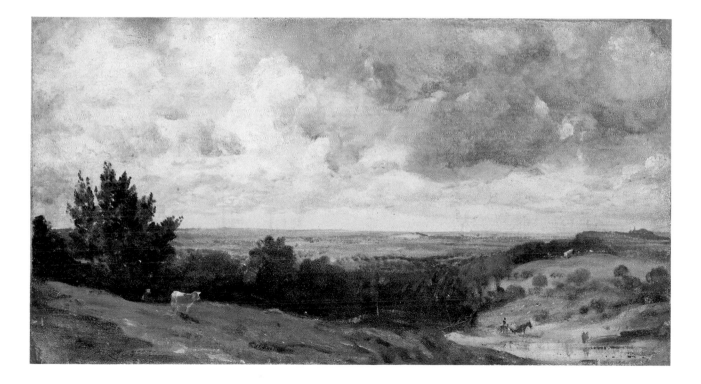

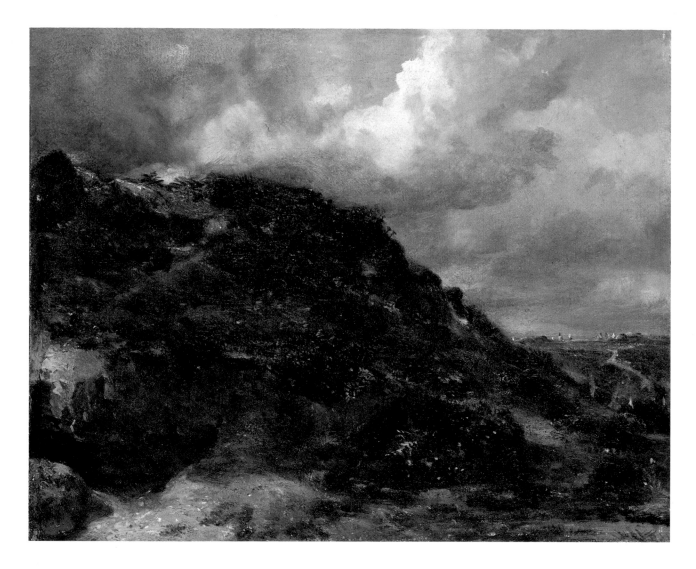

17 *A Bank on Hampstead Heath* c.1820–2
Canvas, $8\frac{1}{8} \times 9\frac{15}{16}$ (206 × 253)
[N 02658]

18 *The Grove, Hampstead*
 *c.*1821–2
 Canvas on board,
 14 × 11⅞ (356 × 302)
 [N 01246]

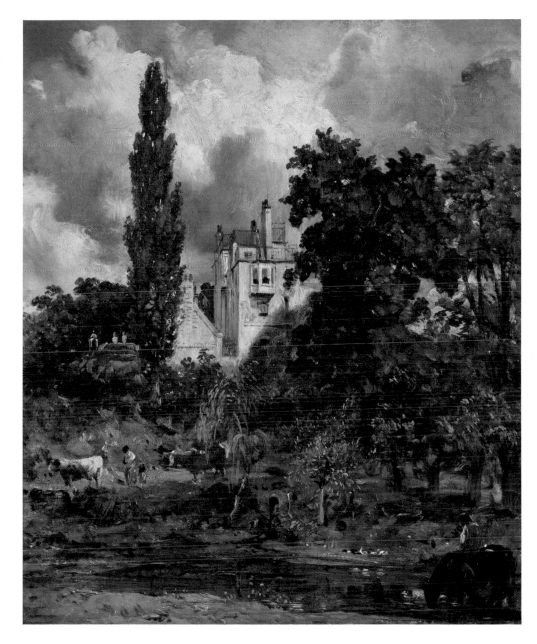

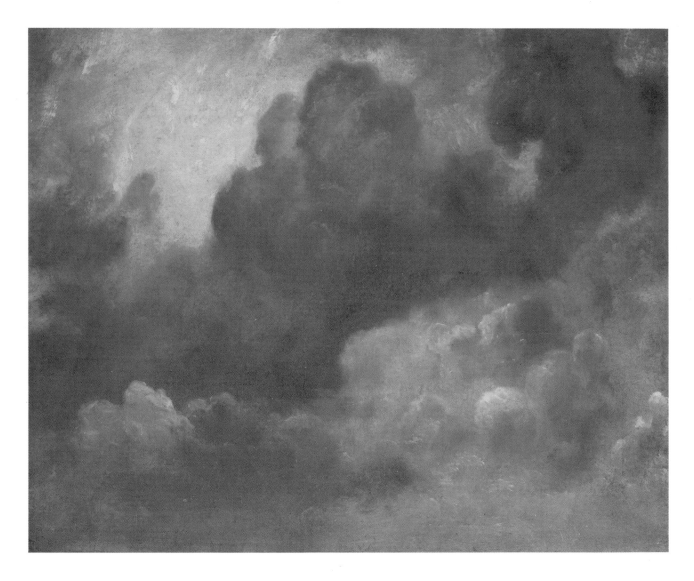

19 *Cloud Study* 1822
 Paper on board, $18\frac{11}{16} \times 22\frac{5}{8}$ (475 × 575)
 [N 06065]

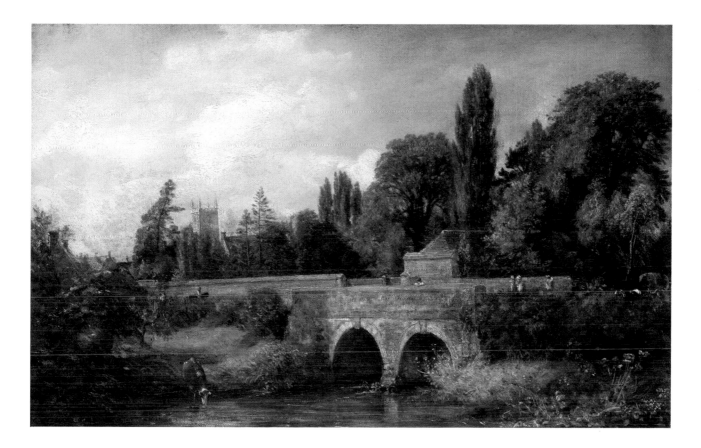

20 *Gillingham Bridge, Dorset* 1823
 Canvas, $12\frac{5}{8} \times 20\frac{1}{4}$ (321 × 515)
 [N 01244]

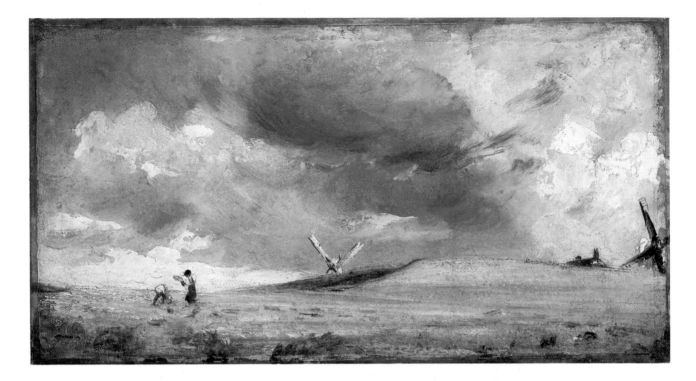

21 *The Gleaners, Brighton* 1824
Paper on canvas, $6\frac{1}{4} \times 11\frac{7}{8}$ (159 × 302)
[N 01817]

22 *Branch Hill Pond, Hampstead Heath,*
 with a Boy Sitting on a Bank *c*.1825
 Canvas, $13\frac{1}{8} \times 19\frac{3}{4}$ (333 × 502)
 [N 01813]

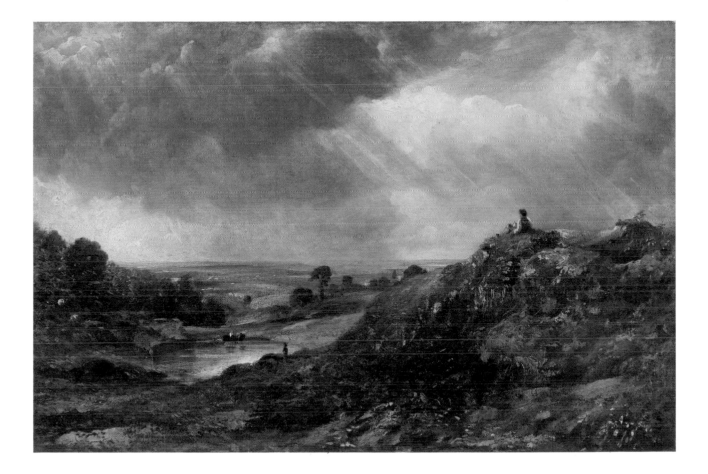

23 *The Sea near Brighton* 1826
Paper on card, $6\frac{13}{16} \times 9\frac{3}{8}$ (173 × 238)
[N 02656]

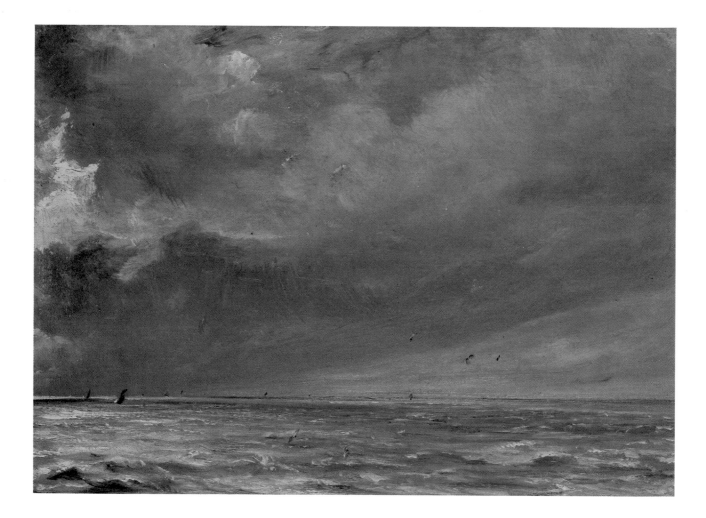

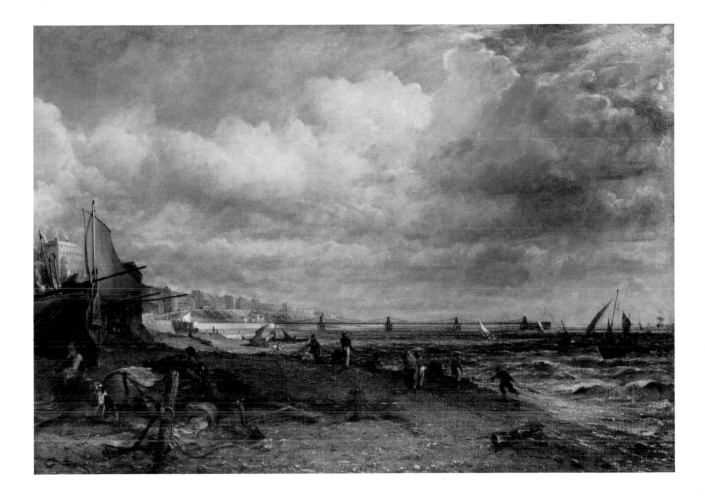

24 *Chain Pier, Brighton* 1826–7
 Canvas, 50 × 72 (1270 × 1830)
 [N 05957]

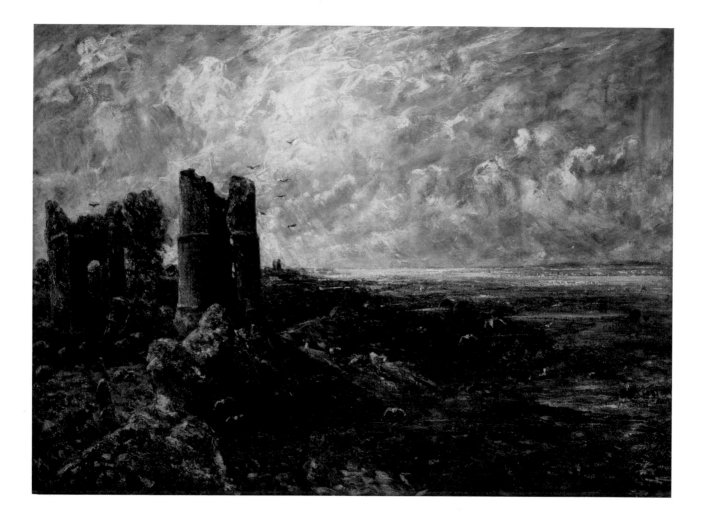

25 *Sketch for 'Hadleigh Castle'* *c*.1828–9
 Canvas, 48¼ × 65⅞ (1225 × 1674)
 [N 04810]

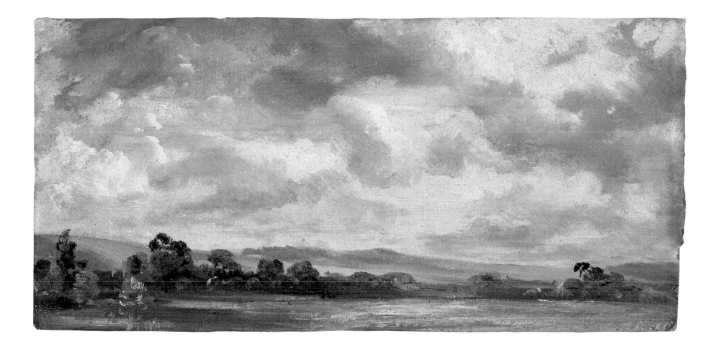

26 *Harnham Ridge, Salisbury* 1820 or 1829
 Paper, $4\frac{1}{2} \times 9\frac{5}{16}$ (114×237)
 [N 01824]

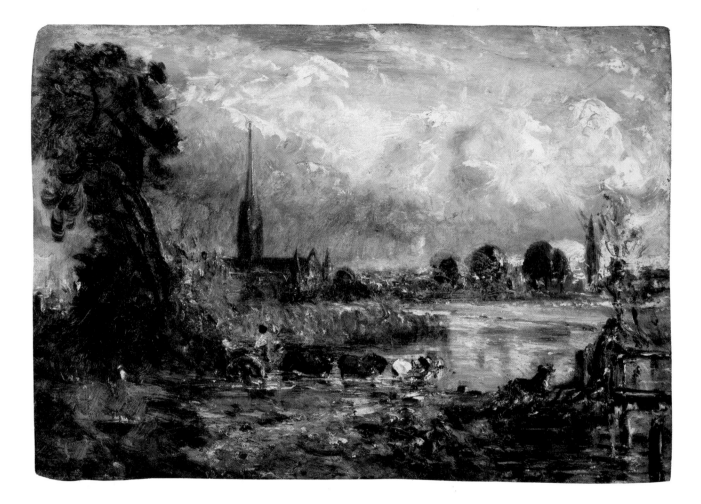

27 *Salisbury Cathedral from the*
 Meadows c.1830
 Canvas, 14¾ × 20⅛ (365 × 511)
 [N 01814]

28 *The Glebe Farm* c.1830
 Canvas, $25\frac{1}{2} \times 37\frac{5}{8}$ (648 × 956)
 [N 01274]

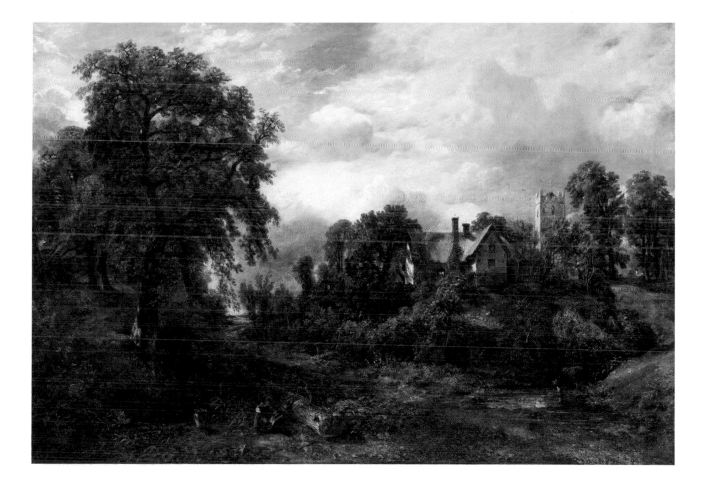

29 *Cloud Study with Verses from Bloomfield* 1830s
Ink, $13\frac{3}{16} \times 8\frac{5}{16}$ (335 × 211)
including verses
[T 01940]

With saunt'ring step he climbs the distant Stile,
Whilst all around him wears a placid smile;
There views the white-rob'd clouds in clusters driven,
And all the glorious pageantry of Heaven.

Lone - in the utmost boundary of the sight,
The rising vapours catch the silver light;
Thence fancy measures - as they portug fly,
Which first will throw its shadow on the eye,
Passing the source of light; and thence away,
Succeeded quick by brighter still than they.

Far yet above these wafted Clouds are seen
(In a remoter sky still more serene)
Others, detach'd in ranges through the Air,
Spotless as snow and countless as they're fair;
Scatter'd immensely wide from east to west, -
The beauteous semblance of a flock at rest.
These to the raptured mind aloud proclaim
Their mighty shepheard's everlasting name.

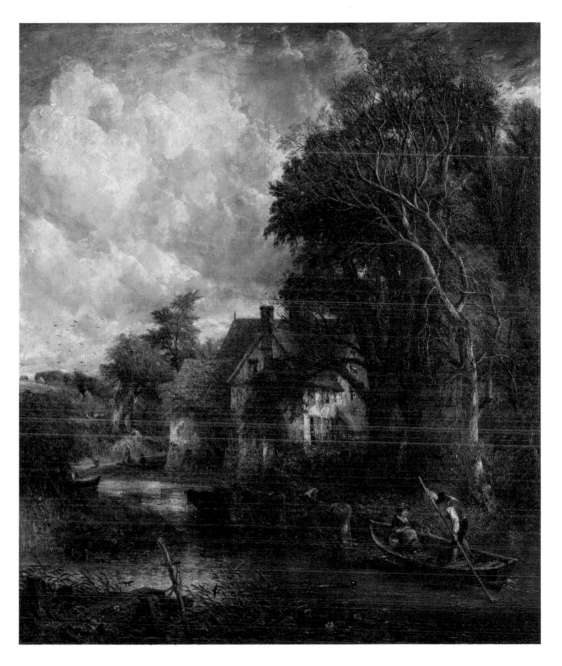

30 *The Valley Farm*
 exh.1835
 Canvas, 58 × 49¼
 (1473 × 1251)
 [N 00327]

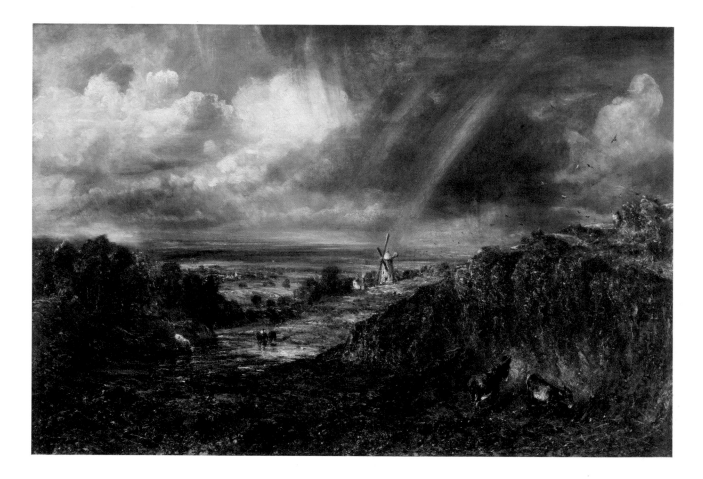

31 *Hampstead Heath with a Rainbow* 1836
Canvas, 20 × 30 (508 × 762)
[N 01275]